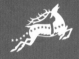

G000081966

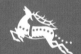

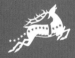

Celebration

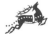

The Christmas Animal Book

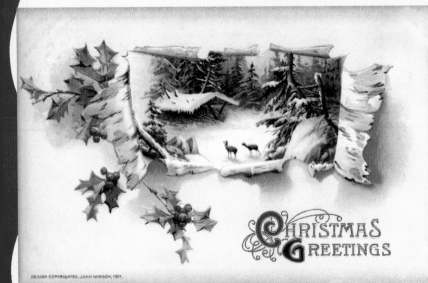

CHRISTMAS GREETINGS

2

To:

From:

Celebration: THE CHRISTMAS ANIMAL BOOK

2007 © Clint Viebrock

978-1-933176-11-6

Published by Red Rock Press
New York, New York

www.redrockpress.com

Library of Congress Cataloging-in-Publication Data

Viebrock, Clint.
 Celebration: the Christmas animal book / by Clint Viebrock.
 p. cm.
 ISBN 978-1-933176-11-6
1. Christmas cards. 2. Animals in art. I. Title.
 NC1866.C5V54 2007
 394.2663—dc22

 2006035267

Printed in Singapore

to

my wife, Susan,
for all her love and her support

Celebration

The Christmas Animal Book

Clint Viebrock

Red Rock Press
New York, New York

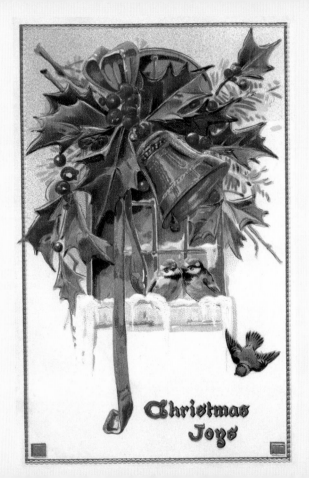

Christmas Joys

Introduction

Sir Henry Cole, the first director of London's Victoria and Albert Museum, found that he had too little time and too many Christmas letters to write. So, in 1843, he commissioned John Calcott Horsley to design a Christmas card, which Horsley then arranged to be printed. This is the first English-language "mass-produced" card that has come down to us.

The Horsley card for Sir Henry depicted a convivial family, including one youngster raising a celebratory glass of Christmastime wine. (Horrors!) Objections were made regarding

a child with a wineglass in his hand, but the idea of a Christmas card eventually caught on. This form of seasonal communication was just too handy to remain dormant for long.

Within a few decades, the sending of Christmas cards was not only an established custom in England, it had also crossed the Atlantic where it was embraced by folks in the United States and Canada, and jumped the Channel to Europe where Germany became a center of card printing in several languages.

By the beginning of the twentieth century, card makers such as Raphael Tuck & Sons and Ernest Nister in England, and John Winsch and Louis Prang in the United States, were turning out hundreds of thousands of Christmas cards annually. (John Winsch created the first card in this book, on the page facing the gift label; Raphael Tuck cards bracket this chapter and appear

elsewhere in the collection; an Ernest Nister card closes
the first chapter.)

Louis Prang, a German immigrant to the United States, had
begun publishing Christmas cards in the 1870s. His company was
known for high quality, multi-colored lithographs featuring
original works by brand-name artists such as Frederick S. Church
and Winslow Homer, with poetry by Longfellow, Tennyson and
William Cullen Bryant. It was said that the lithographs were so
good, artists had difficulty discerning a copy from an original when
the images were hung side-by-side.

In 1872, the U.S. Postal Service authorized postcards,
opening up a new field for card publishers. This book contains
many examples of Christmas postcards, an interesting subset of
the illustrated greeting card phenomenon.

While family gatherings, with pets and presents in abundance, continued to be a popular subject for Christmas card artists, illustrators also reveled in creating seasonal rural scenes featuring both domestic and woodland animals, including birds. There is a certain rationale to this portrayal of rural life: The 1900 U.S. census shows a population of just over 76,000,000, of which fully sixty percent was rural. According to the 1920 census, over half of the 106,000,000 people in America lived in cities.

Country life, then, mirrored the lives of roughly half of the people buying or receiving these holiday cards; for the others, seeing a church steeple or a pastoral scene triggered feelings of nostalgia for a way of life that was passing. Most people then were much closer to both denizens of the barnyard and the forest than we are now.

FAIR BE ALL YOUR DAYS.

It is my hope that this collection of Christmas cards will help you gain a sense of the period they represent, the kinder, gentler days of a century ago.

Gentle Reader, I leave you with one final thought before you peruse the contents. The words are from a favorite Raphael Tuck card: "Fair be all your days."

—Clint Viebrock
Telluride, Colorado

13

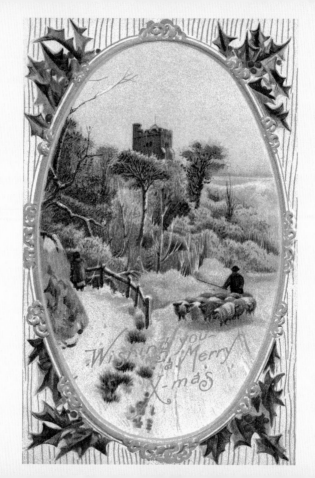

Wishing you a Merry X-mas

Table of Contents

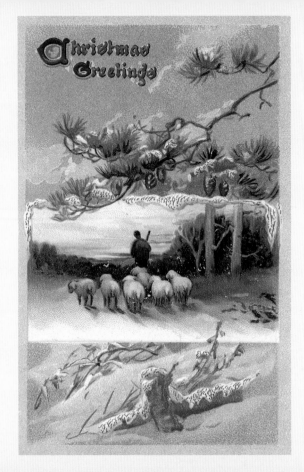

Chapter One

A Barnyard Noel 🦌

Pastoral scenes and domesticated animals in the barnyard are common themes in Christmas cards of the early 1900s.

Your first thought of sheep at Christmastime may be in terms of Christian symbolism: of Jesus' ultimate sacrifice or of a shepherd with his flock on that long-ago night when a bright star signaled a miracle-birth in a manger. However, very few early Christmas cards are overtly religious. They are more related to

hearthside celebration of the holiday and, of course, to the sender's desire to bestow holiday wishes on distant family and friends.

So, while sheep and their minders star in a couple of the most beautiful cards in this collection and may, indeed, hint of long ago shepherds, I suggest that artists chose to paint them to highlight serenely bucolic settings and remind us of how care shown by devoted humans for God's "lesser" creatures is a spiritual act.

Cows not only remind us of once familiar rural life, they especially signify abundance and the contentment of country living. All is well in the world.

Horses and donkeys belonged to this farmyard world, too. They also had other Christmastime roles.

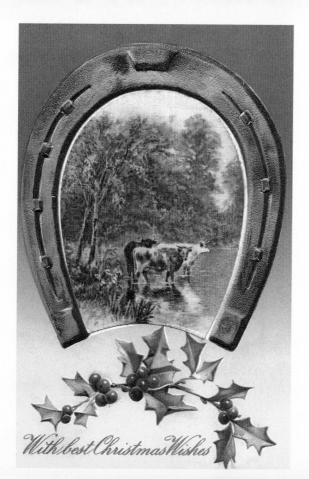

With best Christmas Wishes

19

The donkey has long symbol-ized humility, and it should be noted that Christ rode on a donkey into Jerusalem to complete his earthly mission. Still, donkeys and mules are considered independent, or stub-born and ornery, in ways that open the door to humor.

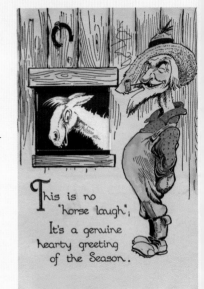

This is no "horse laugh"; It's a genuine hearty greeting of the Season.

The horse, who carried the bur-den of people, and who pulled farm machines, was still key to farm life at the turn of the last century. Census information tells us that in 1915 there were two horses for every three members of the farming population.

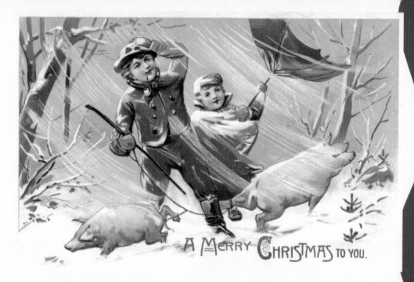

A MERRY CHRISTMAS TO YOU.

Horses represented Fortitude, and they were valued. A horse might enter a barn this time of year as a Christmas gift or find his or her stall decorated with red ribbons or flowers in the spirit of the season.

And then there are the pigs . . .

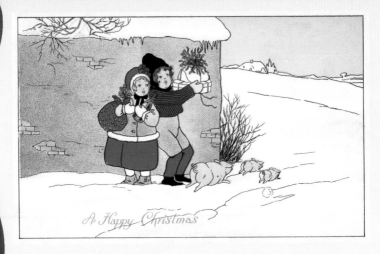

A Happy Christmas

Though many of us regard pigs as stupid, greedy and filthy, the truth is they are quite intelligent. In times past, pigs represented rebirth and rejuvenation, fitting Christmas sentiments.

But then as now, pigs usually did not get the respect they deserve. On old Christmas cards, it is the barnyard animal most likely to be

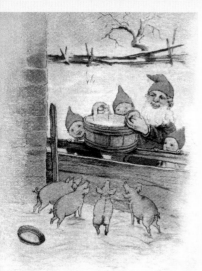

Merry Christmas.

Wishing you a Christmas abundant in Good Cheer!

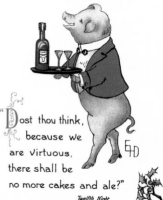

"Dost thou think, because we are virtuous, there shall be no more cakes and ale?"

Twelfth Night.

depicted humorously or, as in a card by the talented Ernest Nister, anthropomorphically.

Make merry, and have a sip of wine.

23

At Christmas Time

May the echo of the angels' song,
Today ring in your ear,
And to your heart bring
joy and peace,
And real and wholesome cheer.

Chapter Two

These Animals Deliver

The animal most associated with Bethlehem is the camel, the beast that transported people of means and their possessions in the desert. The wise men (or three kings) are often pictured riding camels to the birthplace of Jesus, although there is no mention of camels in the gospels of the New Testament.

Contrary to widespread belief, camels do not store water in their humps. However, because they can go for days without water,

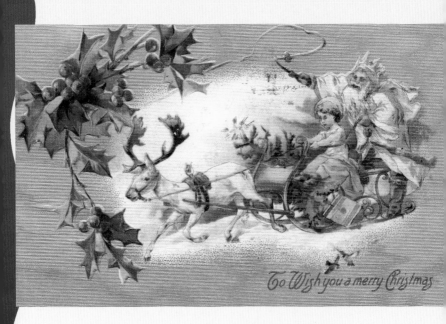

To Wish you a merry Christmas

the animals sometimes symbolize temperance and stamina.
Because the camel is invariably a desert icon, its image has a place
in Christmas card history.

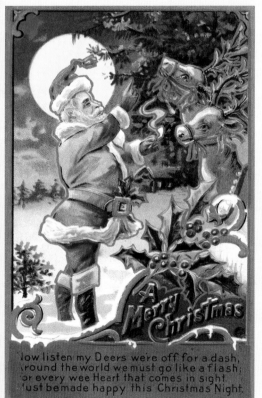

Now listen my Deers were off for a dash,
Around the world we must go like a flash;
For every wee Heart that comes in sight,
Must be made happy this Christmas Night.

The animal most connected to the secular celebration of the holiday is the reindeer. A team of flying reindeer pulling Santa Claus' sleigh, heaped with presents, through the night—who thought that up?

Now listen my Deers we're
off for a dash,
Around the world we must
go like a flash
For every wee heart that
comes in sight
Must be made happy this
Christmas Night

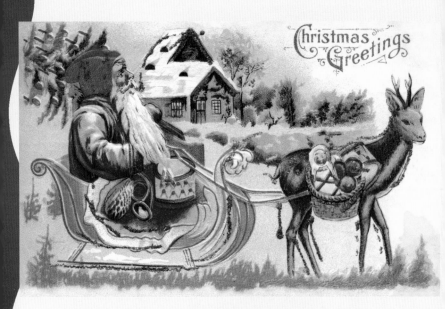

Our contemporary image of Santa and his transportation
mode largely comes from the poem, "A Visit from St. Nicholas,"
published in 1823 by Clement C. Moore. Moore was likely influ-
enced by Washington Irving's descriptions of St. Nicholas, and

possibly by William Gilley, who earlier wrote of airborne reindeer powering Santa's sled.

Small wonder that reindeer appear on many Christmas cards.

But who are these animals, really? Reindeer, once more common in Europe, were domesticated about 15,000 years ago. Today, they're found in the northernmost reaches of Scandinavia. Some Lapps harness and ride reindeers, others use them to pull sleighs or sleds full of heavy goods.

Secular Christmas traditions, it does us well to recall, have arisen from a hodge-podge of sources. To some extent, Santa Claus and his generosity are based on a Fourth Century bishop, Nicholas of Smyrna, said to toss gifts through the windows of poor children. (After he died, Nicholas was sainted.) But clearly much

Merry Christmas to You

about Santa was minted in the Europe of snowy winters, and some ideas predate Christianity. Flying goats pulled Thor's chariot through stormy skies in ancient Norse legend, and such a fleet of goats became attached to Santa in later Scandinavian tales. Later still, and across the Atlantic Ocean, the goats became reindeer.

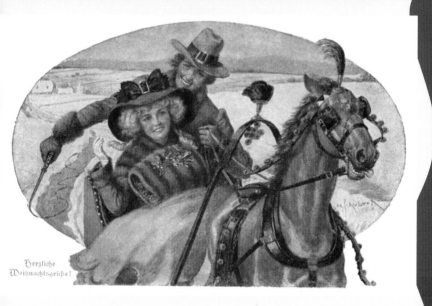

Herzliche
Weihnachtsgrüße!

The Dutch who settled in New York in the seventeenth cen-
tury told stories of Saint Nicholas traveling on horseback, and the
Anglo-American chronicler of New York history, Washington
Irving, referenced these.

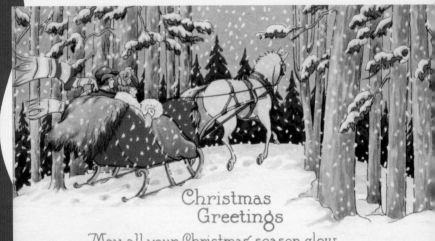

Christmas
Greetings

May all your Christmas season glow
With brightest joys the heart can know.

We spoke of the importance of farm horses in the last chapter, but we revisit them here, in their roles of pulling sleighs through the Christmas snow, or carriages on dry roads, to take families to church or to visit relatives and friends.

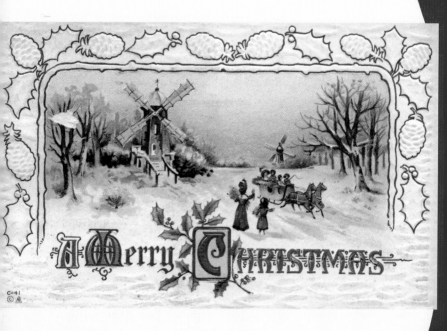

A Merry Christmas

C-41
©A

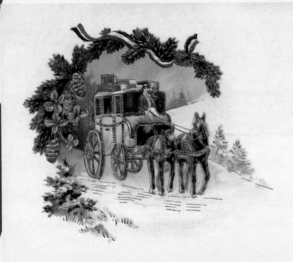

Herzliche
Weihnachts=
grüße

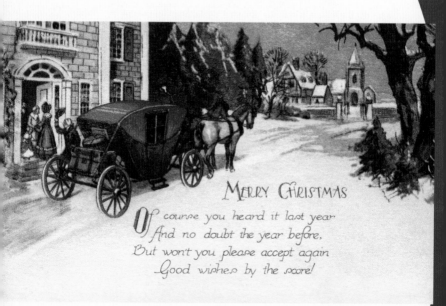

MERRY CHRISTMAS

Of course you heard it last year
And no doubt the year before,
But won't you please accept again
Good wishes by the score!

A century ago, people boarded trains for long trips but still depended on the horse for shorter distances. The car—whose engine would have been described in terms of its horsepower—was a rarity.

The images here of horse-drawn sleighs and carriages in Christmas colors are so vivid we can almost hear the tinkle of their bells.

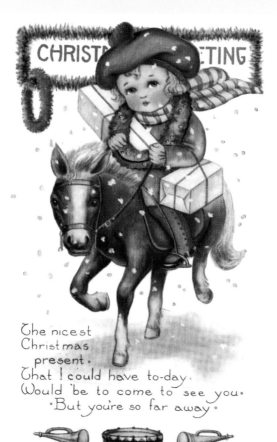

CHRISTMAS GREETING

The nicest
Christmas
present.
That I could have to-day.
Would be to come to see you.
But you're so far away.

37

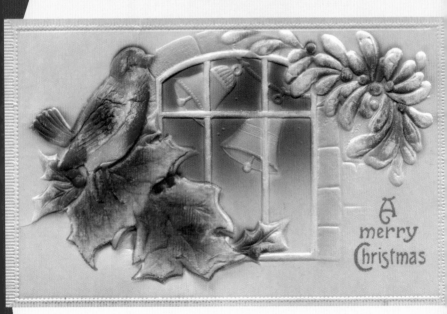

A merry Christmas

Chapter Three

Christmas Birds of a Feather

Birds everywhere! A prelude to an Alfred Hitchcock fantasy? No, antique Christmas cards offer a kinder, gentler presentation of our fine, feathered friends.

We see birds singing in windows, birds on holly branches, birds in the field near the farmhouse. There are robins, finches, jays, bluebirds, and a few too fancifully rendered to identify. Many birds seem to be singing out holiday messages of joy,

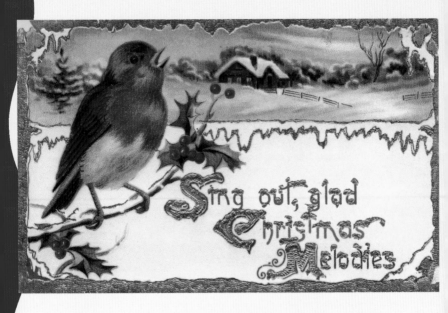

and warbling their wishes for a happy and peaceful New Year.

Birds on cards never seem to mind the cold weather. Their very presence on Christmas cards may be intended not only to

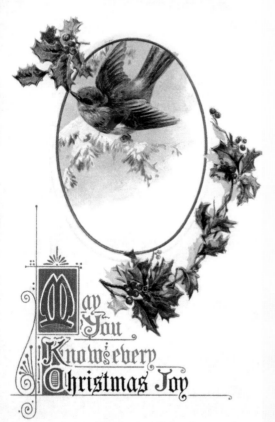

May You Know every Christmas Joy

serenade us, symboli-cally, but also to warm us in the same manner.

Because birds appear to fly so effortlessly, even to soar heavenward, over the ages seers and poets have invested them with near-angelic mean-ing. Birds have been poetic stand-ins for our very souls.

41

And they have variously represented not only swiftness but also enlightenment and prophecy.

The artists who painted the birds on these cards must also have realized that when most of us think of birds, we think of spring. We see a bird in a snowy scene and we understand that although cold weather lies ahead, by December 25 the days have begun to lengthen, and so within

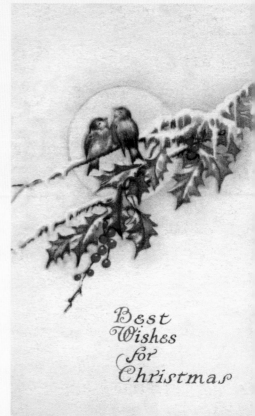

Best Wishes for Christmas

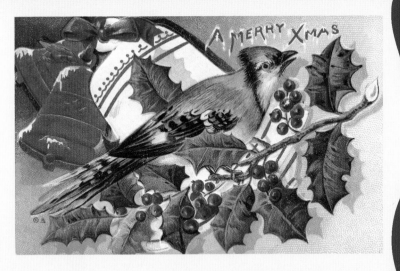

winter is the promise of warmer weather. December 25 is about *hope*, about the significance of the holy baby born that day. A bird in winter is a subtle symbol of hope.

Bluebirds and blue jays, particularly, represent spiritual joy. Sighting a bluebird portends happiness. What a pleasant wish to receive from the sender of a Christmas card.

Here's a wish for
A Merry Christmas
to you and yours:—

Bright and Merry be the day
Filled with Fun and Happy Play!

219

The dove signifies peace. The dove has taken wing in the calm after the storm since the Old Testament days of Noah.

In the Gospels of Matthew and Luke, Jesus uses the sparrow to underline God's love and care for all creatures, saying that even

44

A Merry
Christmas to you.

the lowly sparrow
has His protection.

Finches figure
prominently in old
Christmas cards,
probably for their
brightness of both
feather and song—
an uplifting, even
defiant response to
winter gray.

45

Water fowl—swans and ducks—are pictured in old cards. Even when the banks are snow-covered, their ponds ripple. The penguin, however, did not become a habitué of Christmas card covers until later years.

The same is true of one of the most Christmas-themed birds of all: the partridge in a pear tree. This partridge is the subject of the closing lyric of "The Twelve Days of Christmas," an old French game-song, first published in English in 1780. Memory games were a drawing-room staple on Christmas Eve in Regency England; they must not have been so cherished a century later. Although later than the scope of this book, the partridge in a pear tree has now happily returned to the Yuletide aviary.

The bird seen most often in this collection—and on old Christmas cards, generally—is the robin. The robin is familiar to

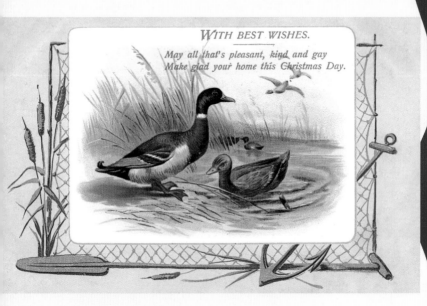

WITH BEST WISHES.

May all that's pleasant, kind and gay
Make glad your home this Christmas Day.

people who live in climates with significant seasonal weather changes. The robin is the bird that most North Americans and Europeans, in real life, are most likely to glimpse. She nests compatibly in both city and country trees. The robin is the messenger who lives among us, and who has also the advantage of having breast feathers of holiday red.

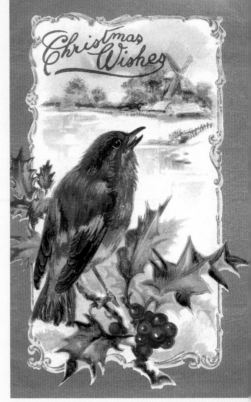

A Flock of Christmas Robins

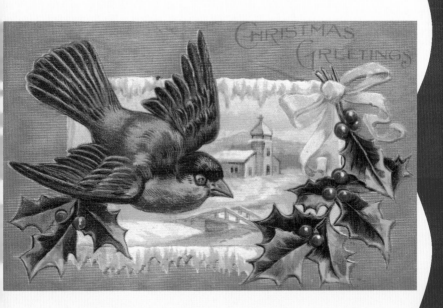

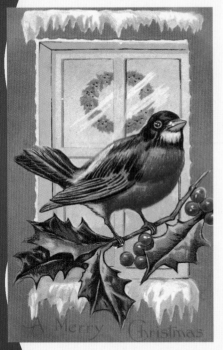

A Merry Christmas

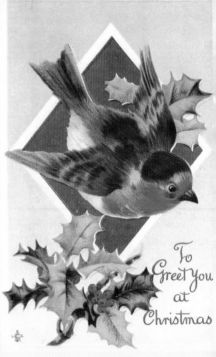

To Greet You at Christmas

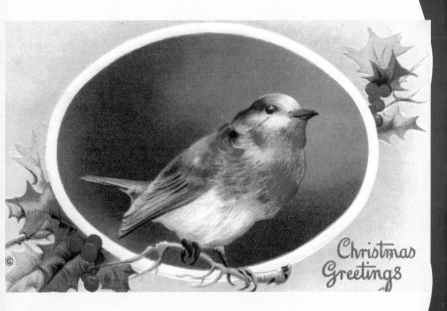

Christmas
Greetings

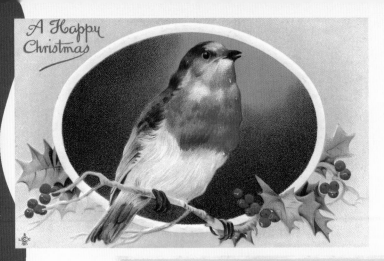

A Happy Christmas

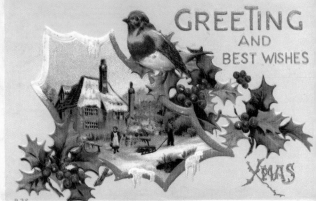

GREETING AND BEST WISHES

XMAS

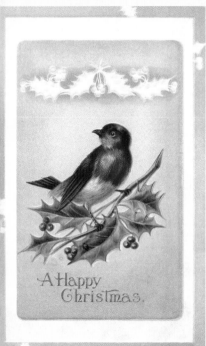

A Happy
Christmas.

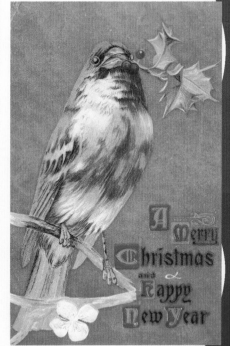

A Merry
Christmas
and a
Happy
New Year

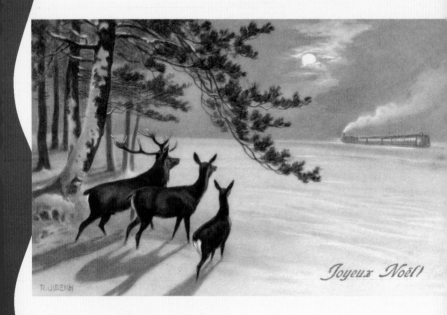

Joyeux Noël!

R. ULREICH

Chapter Four

Woodland Friends
at Christmastime

As intimated on several lovely cards in this little book, nostalgia for the good old days seems to have driven the popularity of using animals of the woods in Christmas illustrations.

Notice how many of the cards show animals relating to humans, either directly or in suggestion. The picture of the three deer watching a departing train is a favorite of mine; it's as if the deer were yearning to connect with the people in the train, or

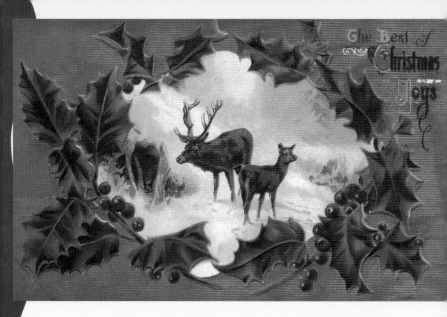

perhaps it is meant to strike us in an opposite manner: the speeding
passengers long for the quiet of the countryside that belongs to the
deer. Similarly, the two deer observing the bringing of the Yule log
seem to be reacting to humans—but again at a safe distance.

A Merry Christmas

C32

In other cards, we see direct contact: the elegant woman and child feeding the fawn, the little girls hand-feeding the squirrels. The pictured connections speak of human generosity, appropriate to the season. But the images are also charmingly naïve, suggesting that unvarying trustworthiness is a human trait, while wild animals are safe, accepting creatures.

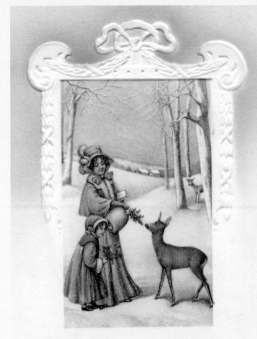

Christmas mirth is fleet and sweet,
May it trip on glancing feet!
Christmas love is deep and strong,
May it bless the whole year long.

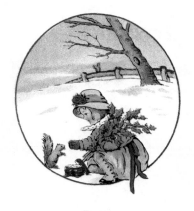

My
Christmas Wish.

I hope that Christmas brings a host
Of all the things you wish for most.

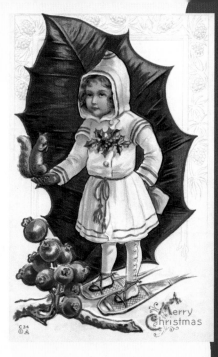

Merry
Christmas

1611/1

Elk and deer are popular Noel images. These warm-blooded animals may have grazed in the high country in summer, but for winter they have returned to warmer altitudes where people tend to live. If the reindeer is hard to find, the more ordinary species of deer are abundant in many places.

The soft-eyed deer is quiet and beautiful to watch standing, leaping or

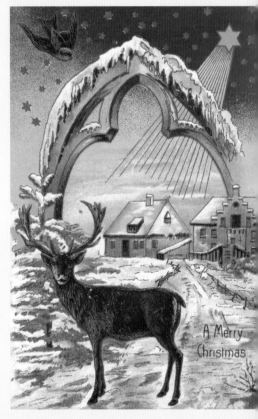

A Merry Christmas

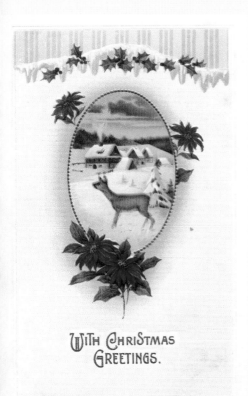

WITH CHRISTMAS GREETINGS.

running. While some gardeners and landscapers must fence deer out, the deer is a peaceable herbivore. Among the qualities attributed to deer are kindness, sensitivity, compassion and graceful gentleness.

The popularity of squirrels on cards may be more connected to how commonplace they are than to anything else. And yes, their cousins,

the mice, are everywhere too, but squirrels usually *stay* outside. Wherever there are trees—city, suburbs or countryside—they make their homes.

It is probably also true that the folkloric virtue of squirrels—their seeming foresightedness in gathering enough acorns and nuts to see them through the winter—may have added to their appeal for some card makers. The image of a

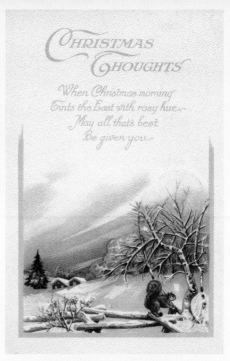

When Christmas morning
Tints the East with rosy hue
May all the best
Be given you.

Христосъ Воскресе!

squirrel might be equivalent to a hope for plentitude. Seen that way, the squirrel conveys a wish for a bountiful Christmas and prosperous New Year.

Credits

Cover: Engraved and gilded, U.S., 1910; p. 2: Embossed, illustration by John Winsch on a U.S. card posted in 1911; p. 8: "Christmas Snows"—Series No. 503, Raphael Tuck & Sons, London, posted Christmas Eve in Victor, N.Y., 1909; p. 13: Raphael Tuck & Sons, London; p. 14: Embossed and silvered, posted in Toledo, Ohio, 1911; p. 16: "Christmas Snows"—Series No. 503, Raphael Tuck & Sons, London, printed in Saxony; p. 19: Embossed and printed in Germany, addressed to a lady in Dalton, Ohio; p. 21: Embossed, Raphael Tuck & Sons, London; p. 22: Gold Medal Art, New York, posted Christmas Eve in Kennebunk, Me., 1913; p. 23 (left): Engberg-Holmberg Publishing Co., Chicago, posted in Fertile, Minn., 1906; (right): Designed by Ernest Nister, London, published by E. P. Dutton, New York, printed in Bavaria; p. 24: Made in U.S., posted in Louisiana, 1923; p. 26: Embossed, created by United Art Publishing in New York and printed in Germany, posted in Youngstown, Ohio, 1907; p. 27: Embossed and gilded, "Kris Kringle Series #1," U.S.; p. 28: Glittered, made in Austria, posted in Illinois, 1908; p. 30: Embossed, Whitney Made, Worcester, Mass., undated, hand-delivered; p. 31: Pantoophal, Vienna; p. 32: U.S.; p. 33: Embossed, U.S., 1912; p. 34: Gilded, Hoghl.m.gold, Netherlands, 1919; p. 35: U.S.; p. 37: Embossed, Whitney Made, Worcester, Mass.; p. 38: Embossed, printed in Germany, 1911; p. 40: Gilded, made in Germany; p. 41: Embossed, used in Elbhart, Ind.; p. 42: Made in U.S.; p. 43: Embossed and gilded, Christmas Series No. 14; p. 44: Series 219; p. 45: Embossed with glitter, printed in Germany, posted in Illinois; p. 47: Published by A.M. & Co., London; p. 48: Printed in England and posted in Canada, 1916; p. 49: Embossed and gilded, printed in the U.S., and posted in Woodmere, N.Y., 1908: p. 50 (left): Embossed and gilded, printed in the U.S. and posted in New Rochelle, N.Y., 1908; (right): Embossed, Gold Standard, U.S.; p. 51: Embossed, addressed to Syracuse, Ind.; p. 52 (top): Embossed; (bottom): Embossed, posted in Portland, Ore.; p. 53 (left): Printed in Meeker, N.Y., posted in 1910; (right): Embossed and gilded, made for S. H., Knox & Co., posted in Kansas City, 1909; p. 54: Embossed, posted in West Philadelphia; p. 56: M. Munk, M.M. Vienne, posted in Belgium, 1915; p. 57: Embossed, U.S., 1912; p. 58: Printed in Vienna, 1911; p. 59: Bergman & Co., embossed, posted in Frankfort, N.Y., 1915; p. 60: Embossed, printed in Germany, posted in Moline, Ill., 1909; p. 61: Embossed, printed in Germany, used in the U.S., 1914; p. 62: Made in U.S., posted in U.S., 1921; p. 63: Posted in Bulgaria, 1910; Back cover: Dtuck, Germany

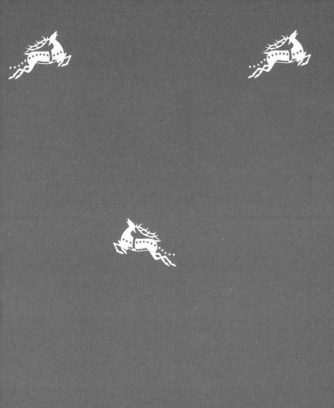